마르크 보고 있는 것이 되었다. 그런 사람들은 사람들은 사람들은 사람들은 사람들은 사람들이 되었다. 그런 사람들은 사람들은 사람들은 사람들은 사람들은 사람들은 사람들은 사람들은

MODERN MONOGRAMS

1310 GRAPHIC DESIGNS

KIYOSHI TAKAHASHI

DOVER PUBLICATIONS, INC. NEW YORK

NK 3640 .T3 1985

Copyright © 1979 by Typony Inc.

All rights reserved under Pan American and International Copyright Conventions.

Published in Canada by General Publishing Company, Ltd., 30 Lesmill Road, Don Mills, Toronto, Ontario.

Published in the United Kingdom by Constable and Company, Ltd., 10 Orange Street, London WC2H 7EG.

This Dover edition, first published in 1985, is an unabridged republication of the work originally published by Typony Inc., New York, in 1979 under the title *Modern Monograms*.

DOVER Pictorial Archive SERIES

Modern Monograms: 1310 Graphic Designs belongs to the Dover Pictorial Archive Series. Up to ten illustrations from this book may be reproduced on any one project or in any single publication free and without special permission. Wherever possible, include a credit line indicating the title of this book, author and publisher. Please address the publisher for permission to make more extensive use of illustrations than that authorized above.

The republication of this book in whole is prohibited.

Manufactured in the United States of America. Dover Publications, Inc., 31 East 2nd Street, Mineola, N.Y. 11501

Library of Congress Cataloging in Publication Data

Takahashi, Kiyoshi, 1940-Modern monograms.

(Dover pictorial archive series)
Reprint. Originally published: New York: Typony, c1979.

1. Monograms. I. Title. II. Series.

NK3640.T3 1985 686.2'24 84-18740
ISBN 0-486-24788-0 (pbk.)

LONGWOOD COLLEGE
FARMVILLE, VIRGINIA 23901

Contents

Introduction	. 5
The Letter A	. 7
The Letter B	13
The Letter C	19
The Letter D	25
The Letter E	31
The Letter F	37
The Letter G	43
The Letter H	49
The Letter I	55
The Letter J	61
The Letter K	67
The Letter L	
The Letter M	79
The Letter N	85
The Letter O	91
The Letter P	97
The Letter Q	03
The Letter R	07
The Letter S	
The Letter T	
The Letter U	
The Letter V	31
The Letter W	37
The Letter X	
The Letter Y	48
The Letter Z	
Examples	

Introduction

Type is today's universal communications tool. It is as important to the writer, whose message it communicates through meaning, as it is to the designer, who seeks to communicate the same message, reinforced and amplified by its visual impact.

With the development of phototype, thousands of interesting new type faces have become practical. Flare, shadow and three-dimensional design are being widely used; so are spacing variations like overlapping, interlocking and touching arrangements. An almost infinite number of choices is now available to today's designer.

This book has been developed to offer today's designer the quickest and yet the widest possible survey of modern type approaches. It is based on a selection from the hundreds of type faces currently available. In the form of monograms or logos arranged in convenient alphabetical order, it will serve you both as a source of complete, immediately useful designs—and as an inspiration... a useful starting point from which you can develop and refine your own original creative type solutions.

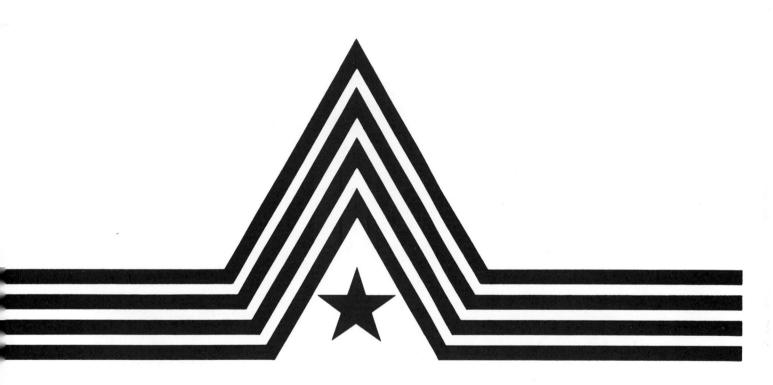

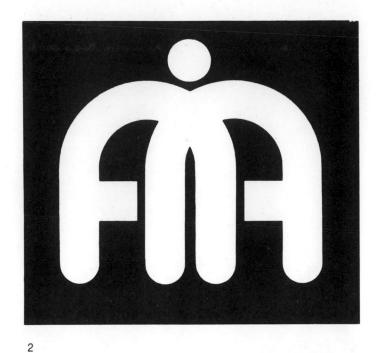

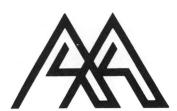

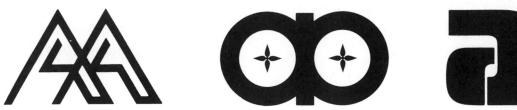

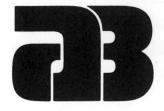

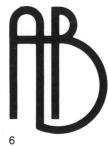

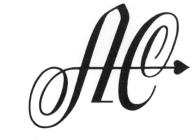

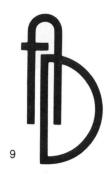

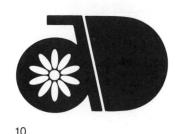

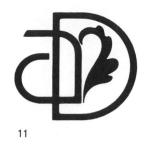

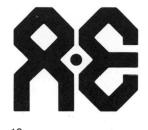

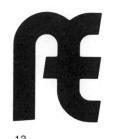

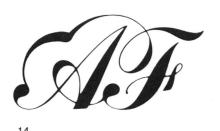

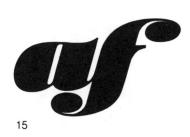

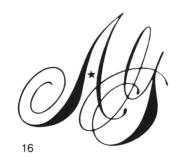

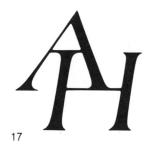

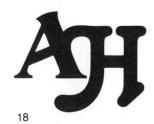

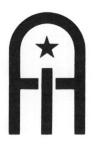

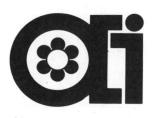

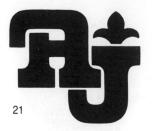

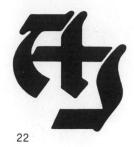

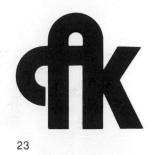

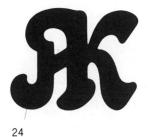

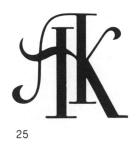

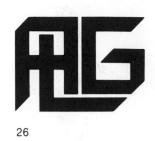

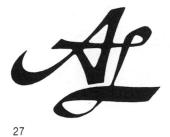

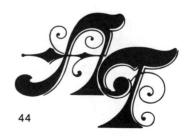

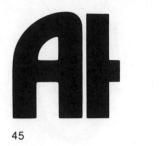

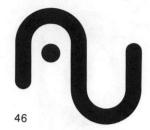

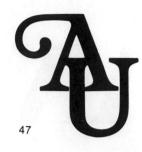

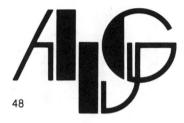

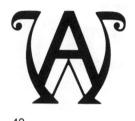

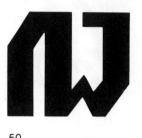

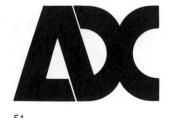

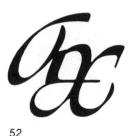

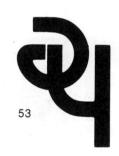

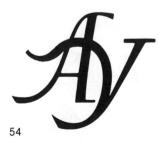

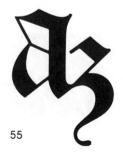

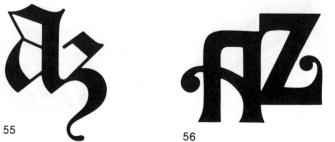

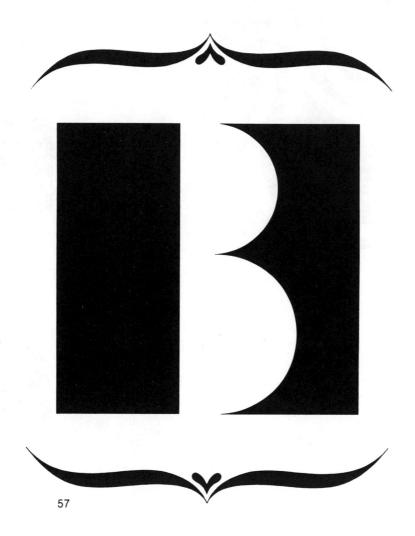

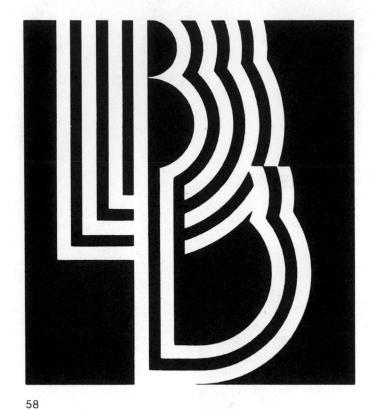

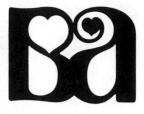

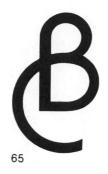

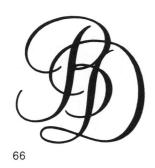

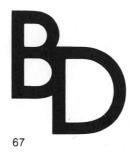

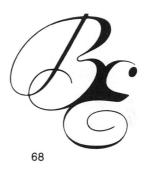

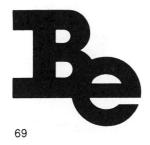

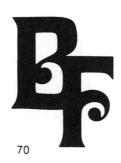

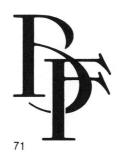

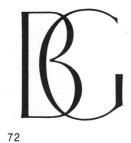

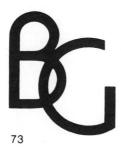

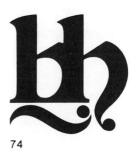

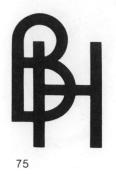

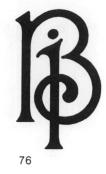

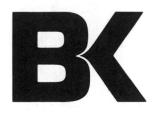

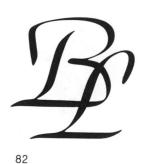

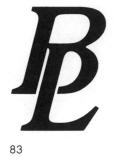

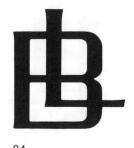

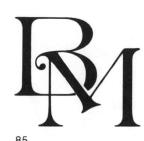

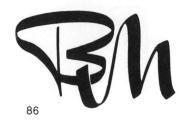

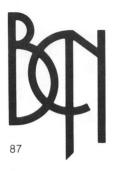

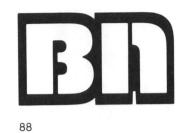

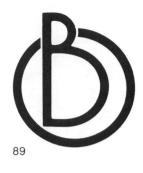

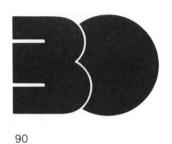

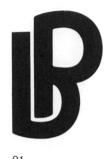

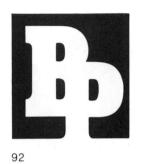

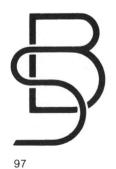

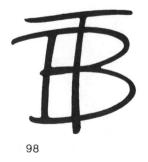

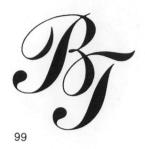

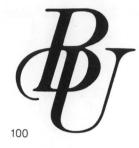

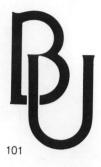

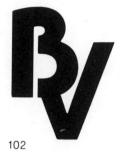

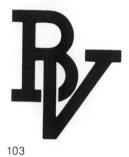

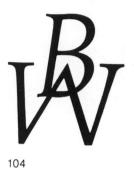

B

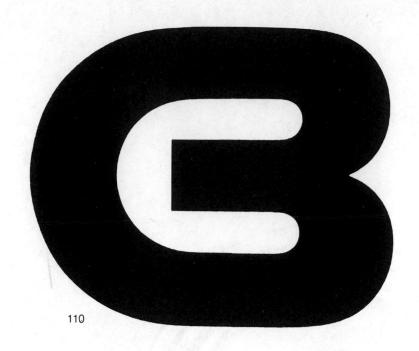

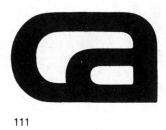

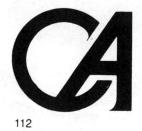

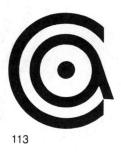

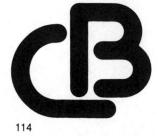

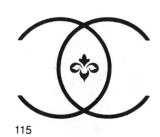

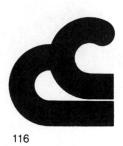

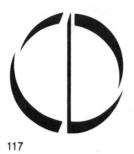

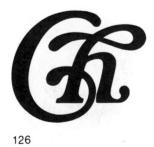

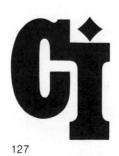

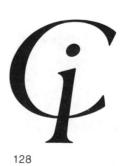

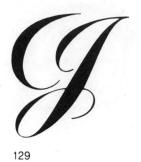

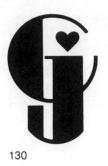

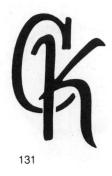

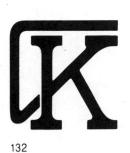

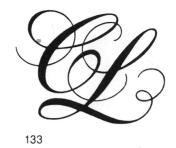

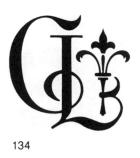

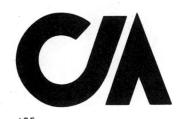

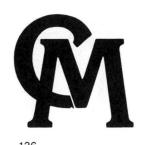

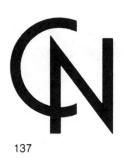

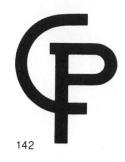

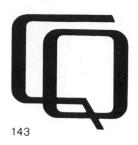

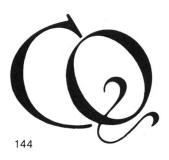

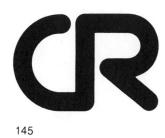

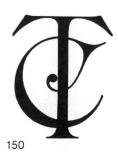

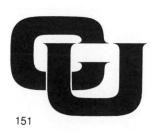

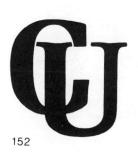

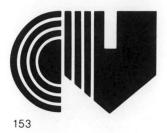

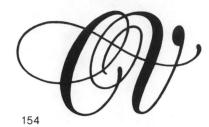

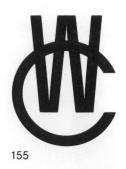

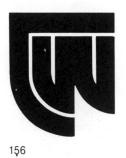

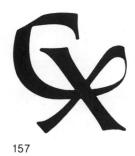

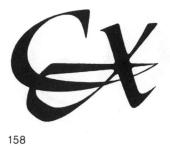

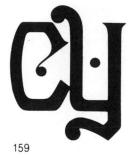

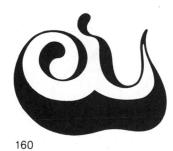

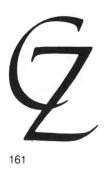

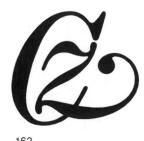

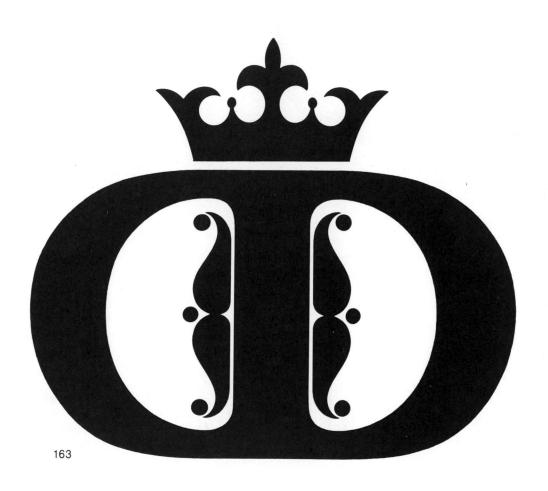

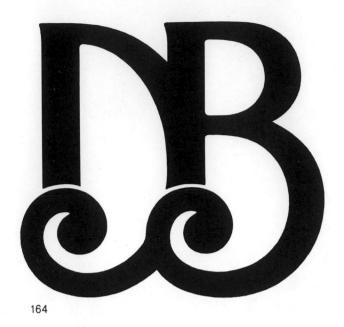

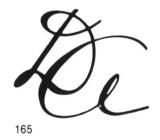

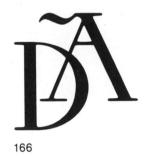

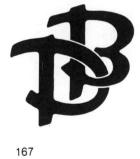

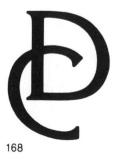

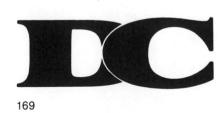

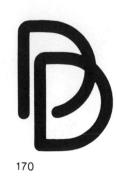

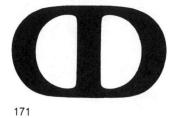

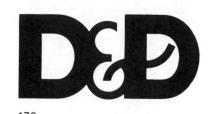

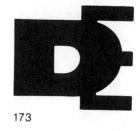

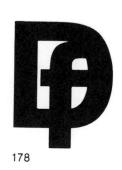

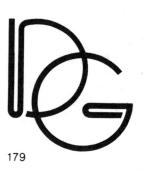

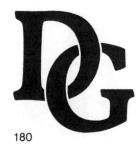

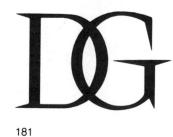

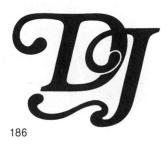

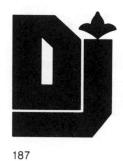

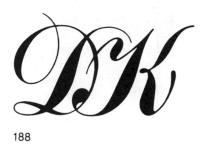

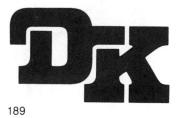

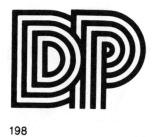

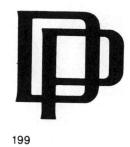

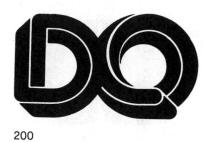

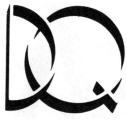

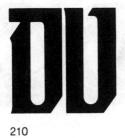

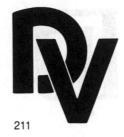

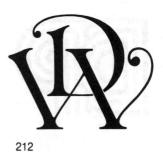

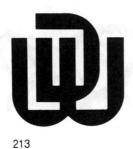

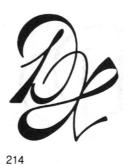

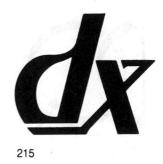

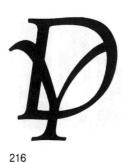

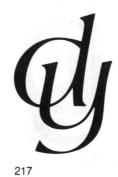

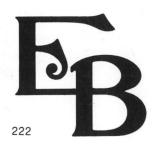

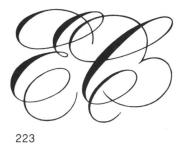

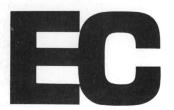

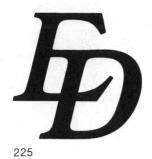

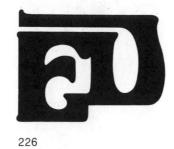

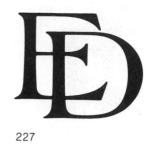

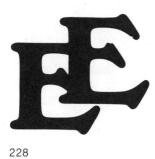

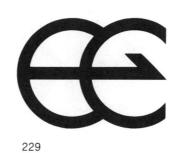

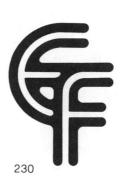

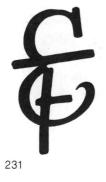

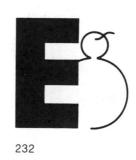

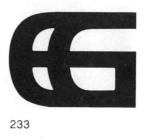

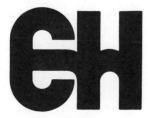

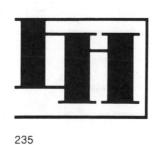

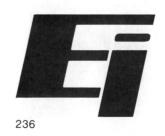

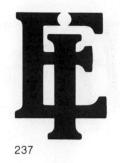

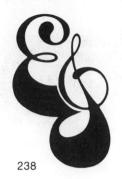

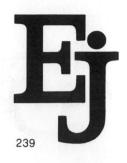

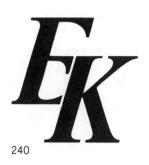

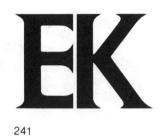

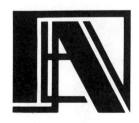

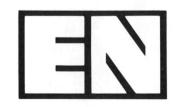

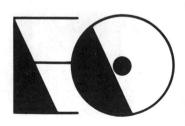

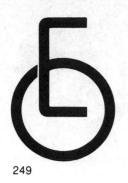

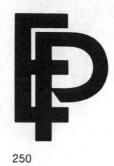

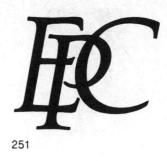

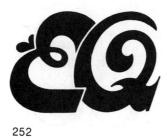

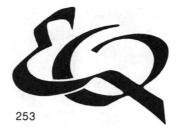

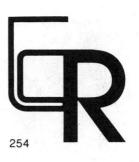

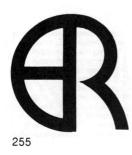

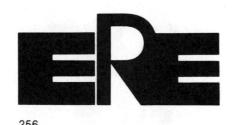

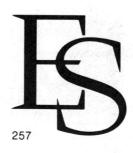

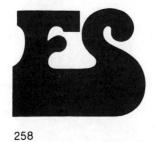

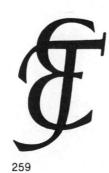

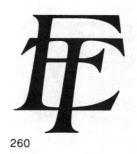

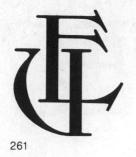

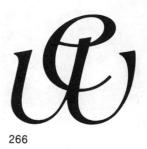

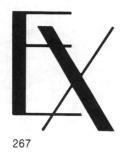

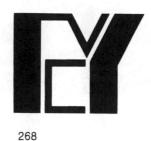

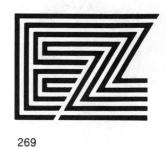

VALUE V

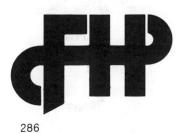

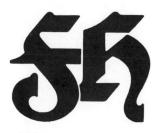

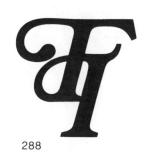

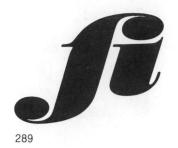

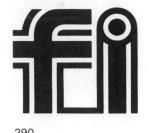

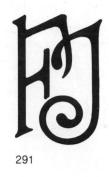

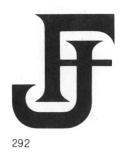

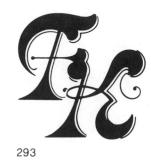

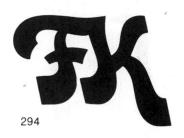

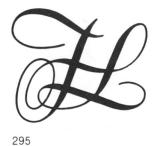

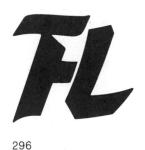

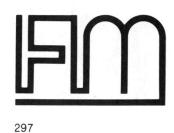

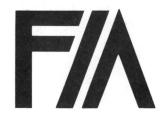

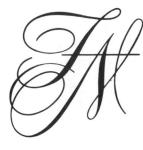

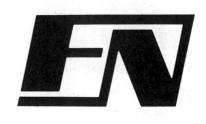

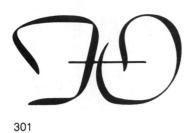

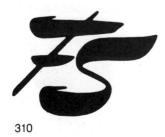

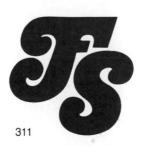

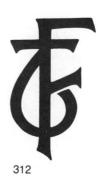

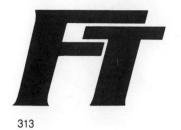

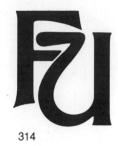

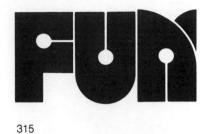

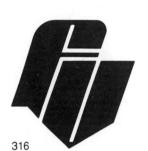

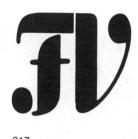

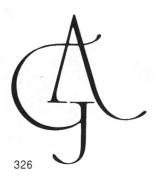

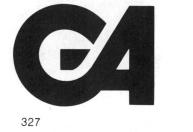

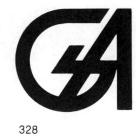

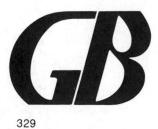

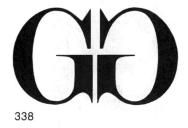

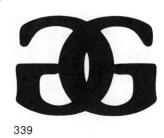

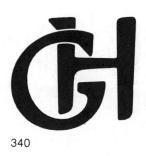

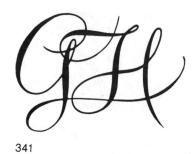

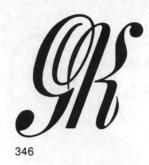

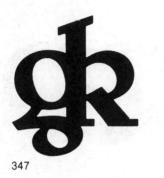

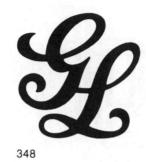

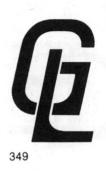

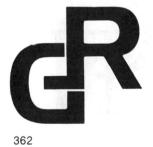

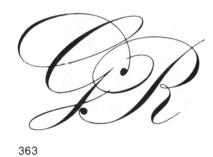

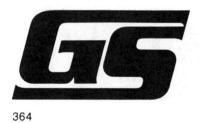

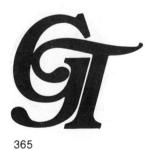

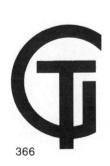

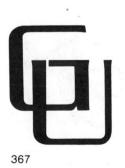

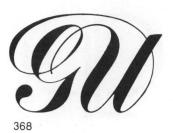

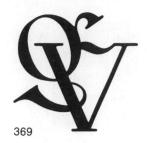

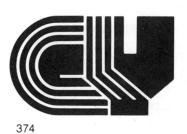

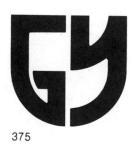

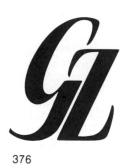

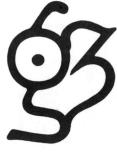

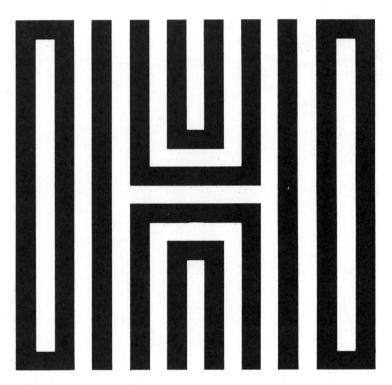

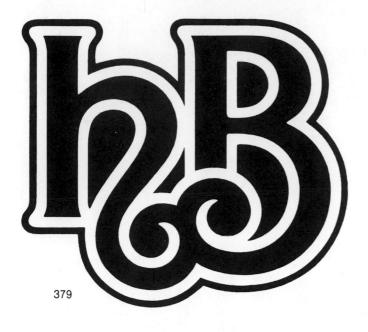

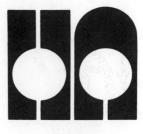

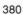

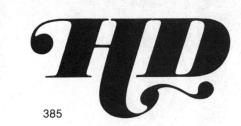

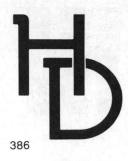

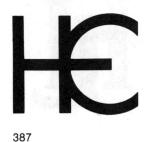

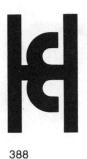

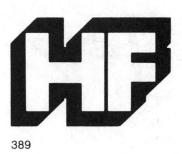

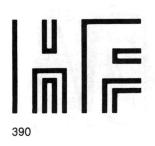

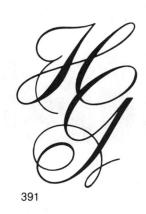

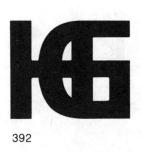

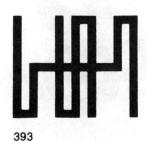

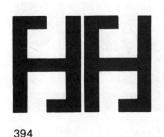

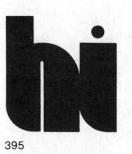

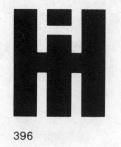

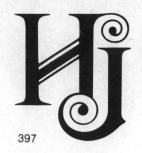

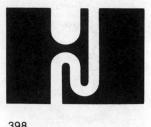

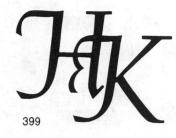

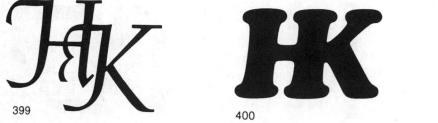

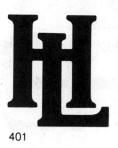

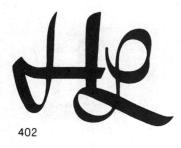

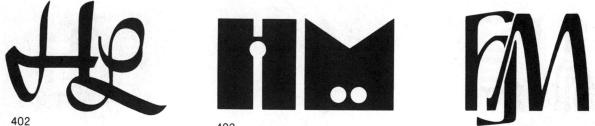

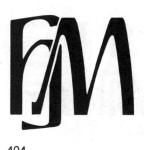

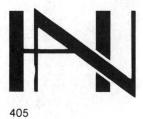

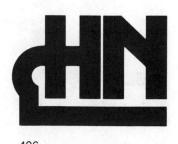

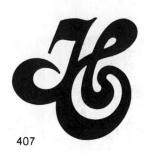

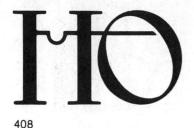

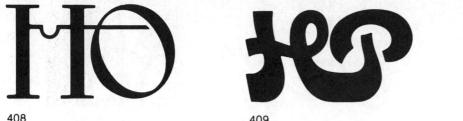

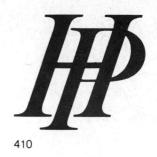

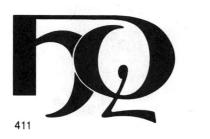

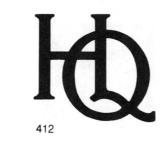

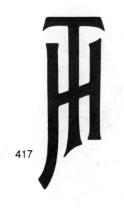

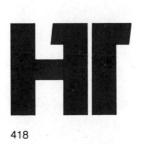

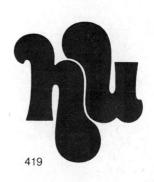

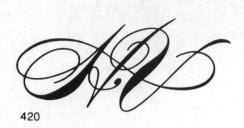

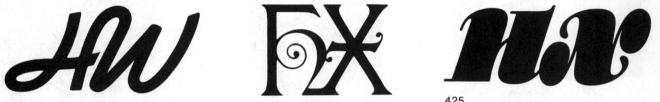

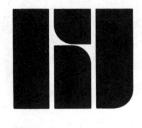

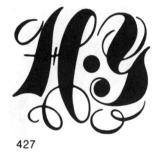

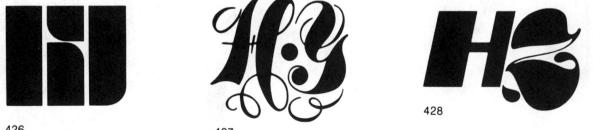

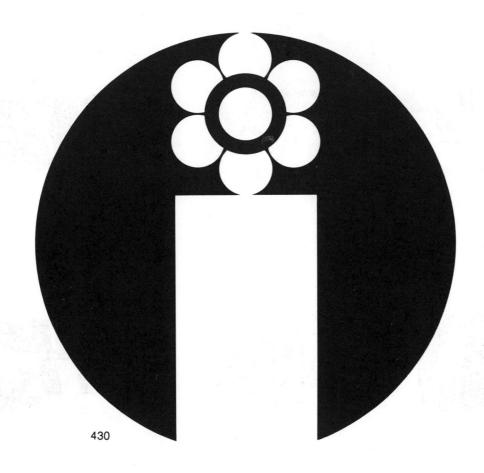

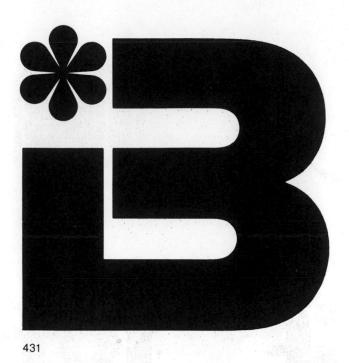

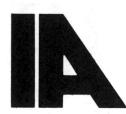

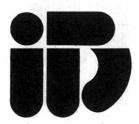

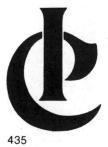

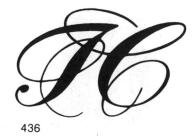

D

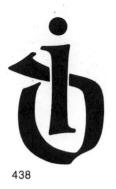

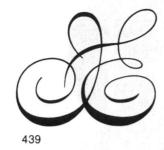

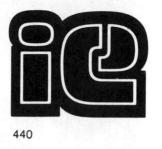

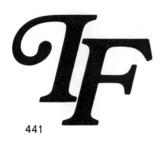

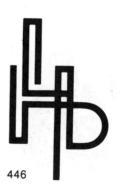

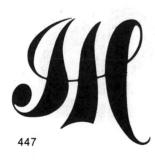

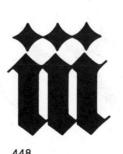

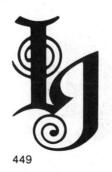

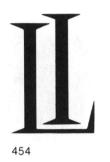

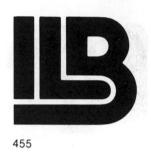

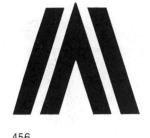

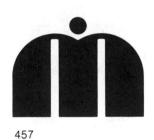

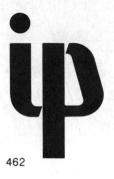

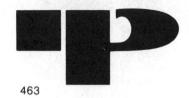

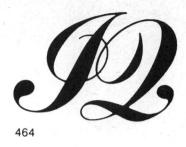

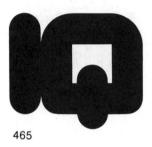

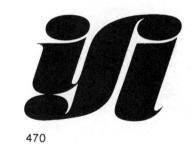

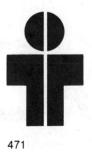

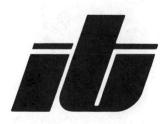

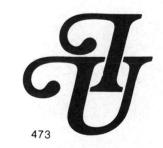

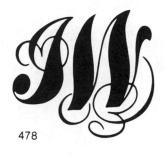

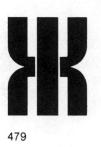

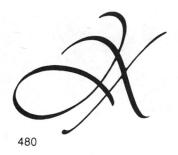

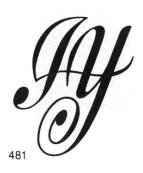

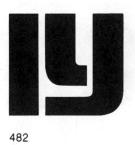

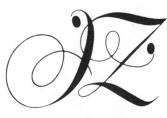

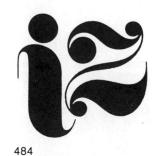

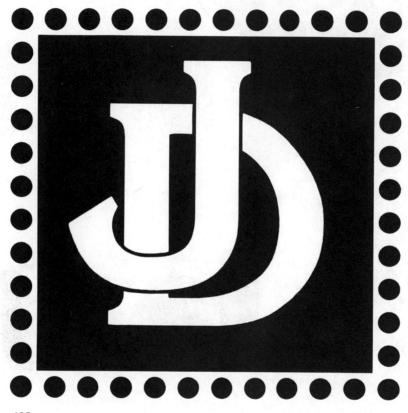

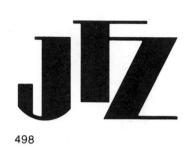

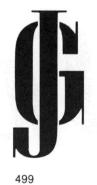

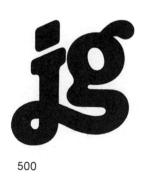

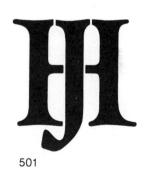

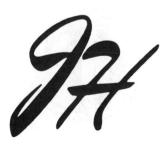

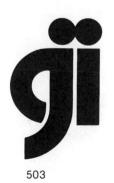

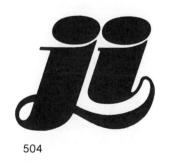

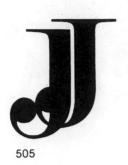

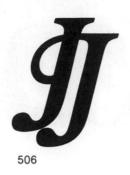

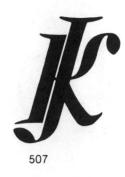

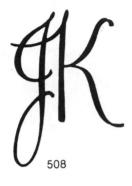

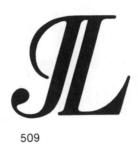

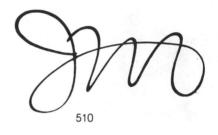

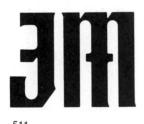

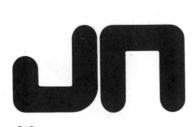

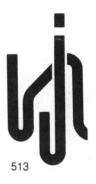

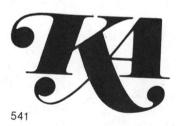

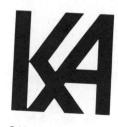

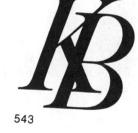

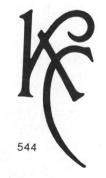

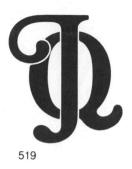

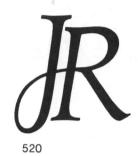

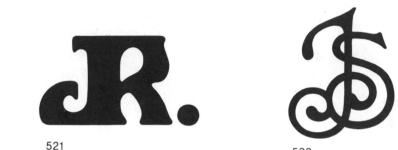

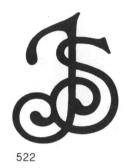

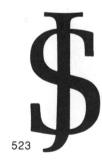

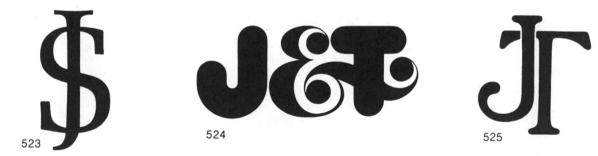

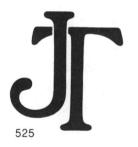

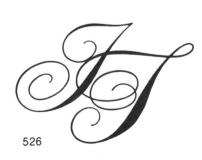

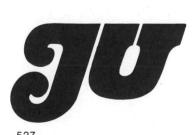

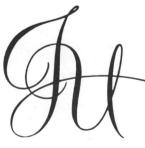

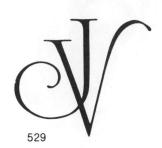

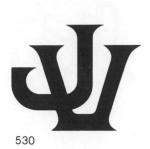

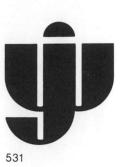

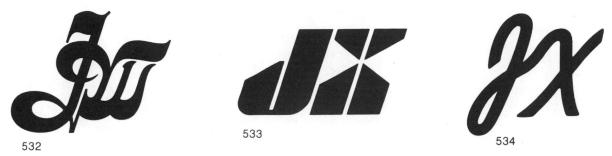

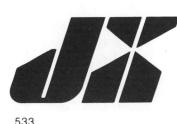

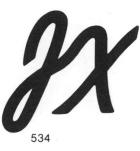

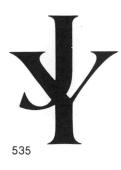

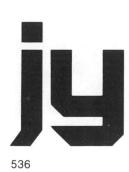

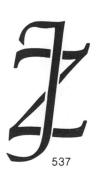

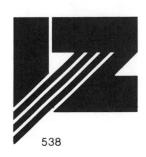

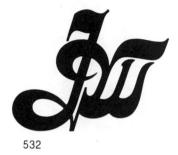

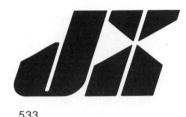

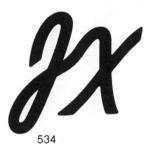

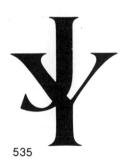

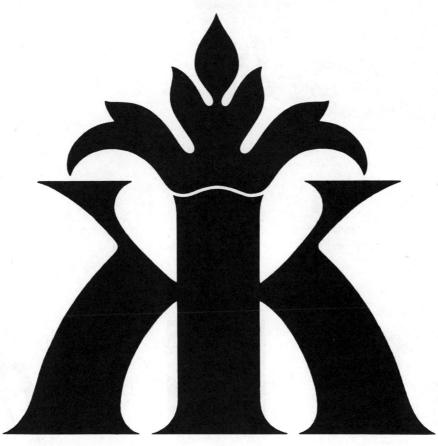

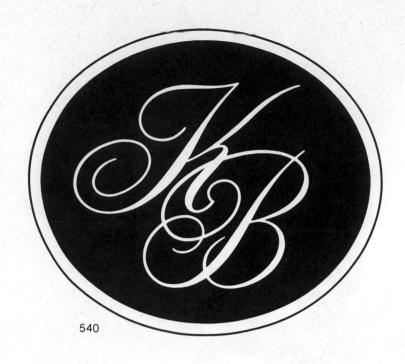

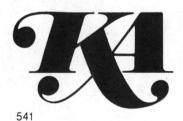

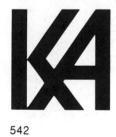

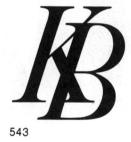

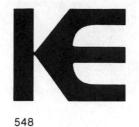

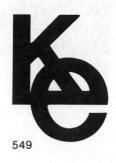

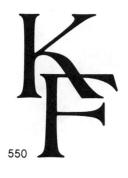

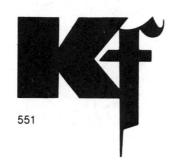

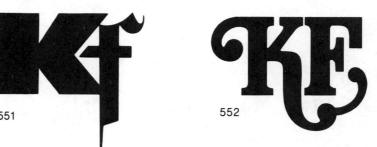

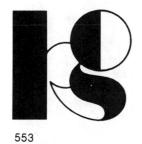

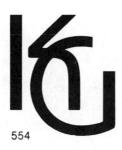

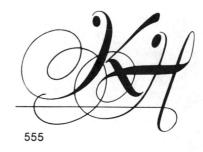

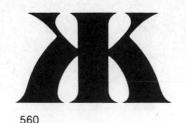

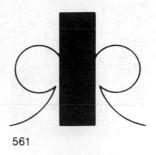

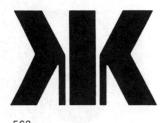

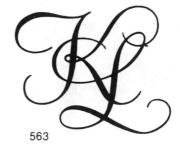

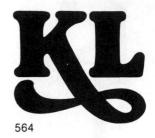

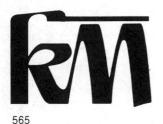

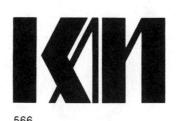

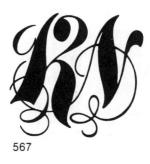

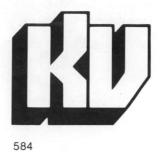

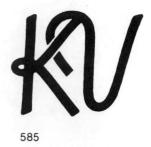

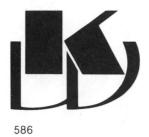

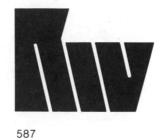

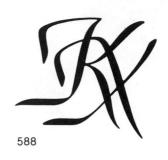

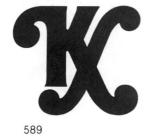

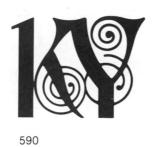

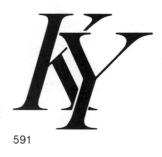

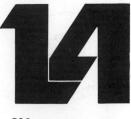

M

P

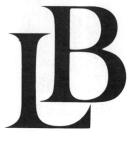

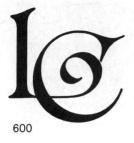

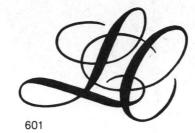

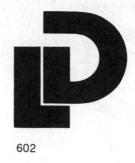

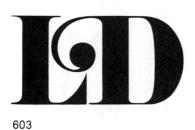

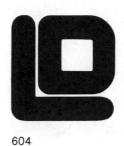

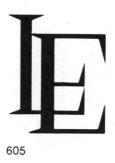

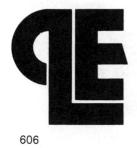

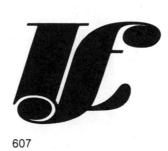

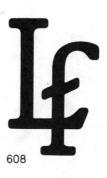

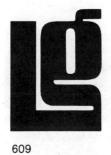

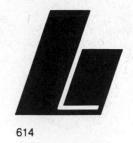

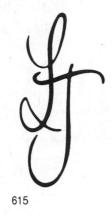

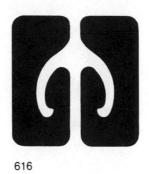

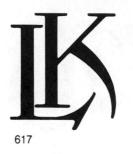

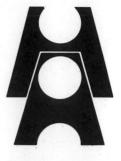

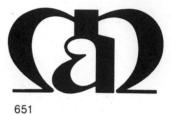

S

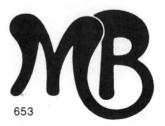

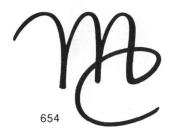

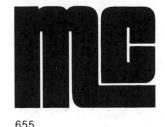

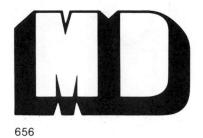

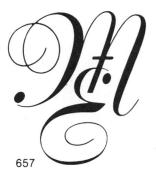

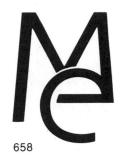

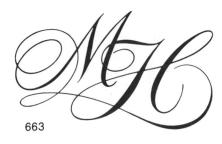

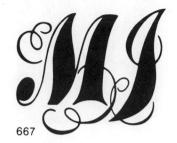

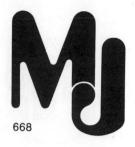

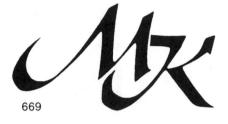

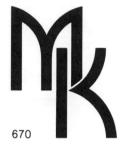

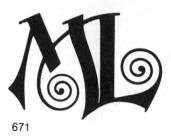

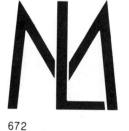

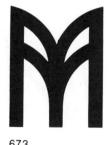

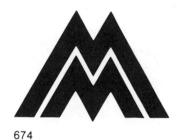

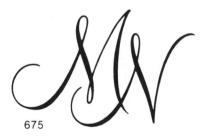

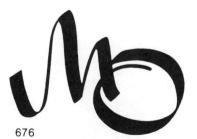

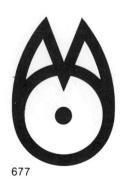

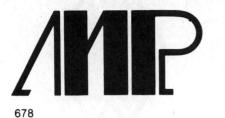

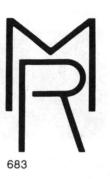

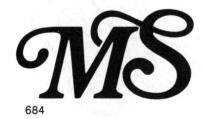

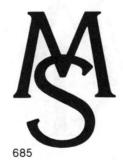

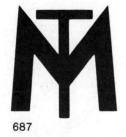

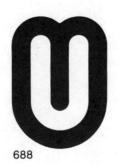

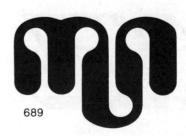

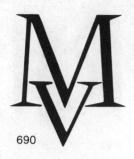

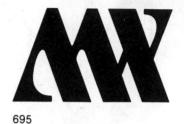

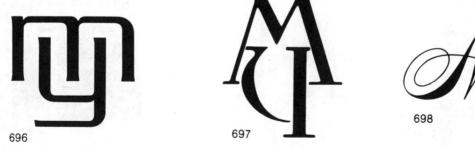

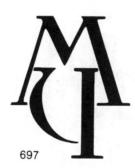

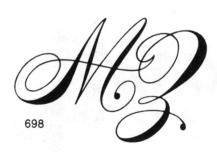

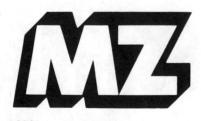

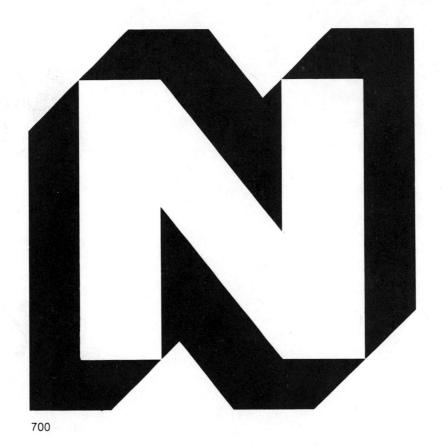

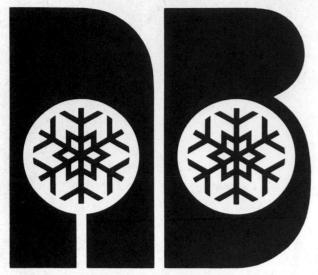

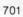

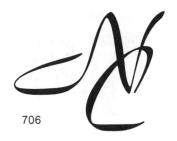

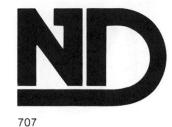

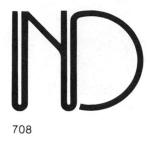

NE

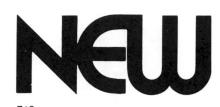

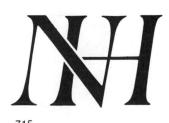

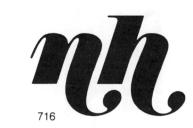

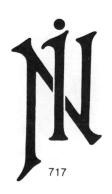

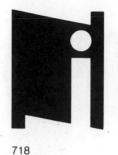

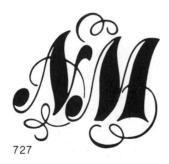

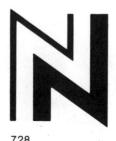

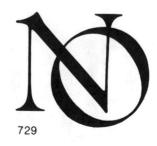

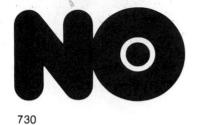

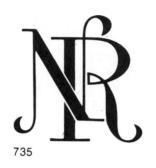

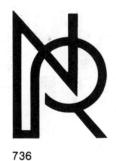

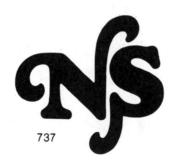

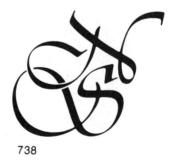

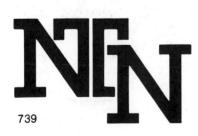

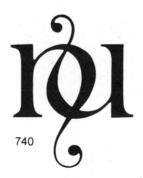

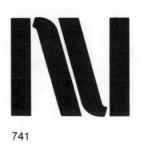

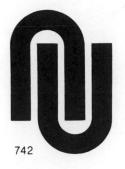

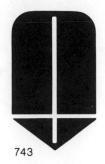

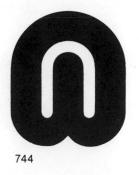

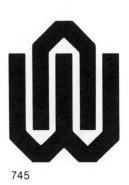

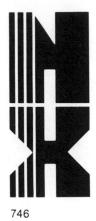

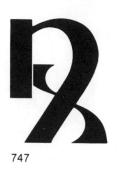

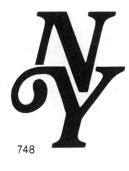

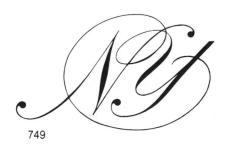

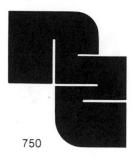

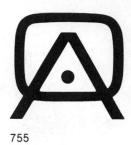

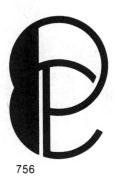

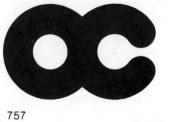

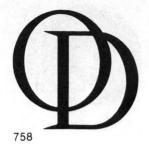

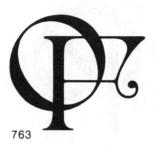

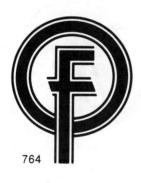

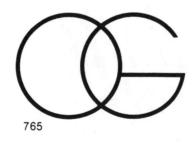

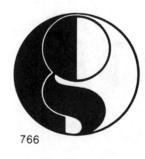

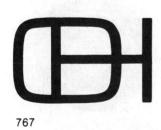

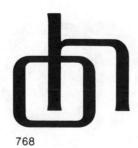

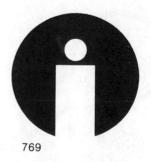

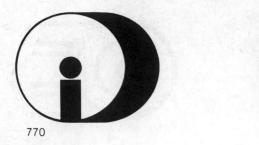

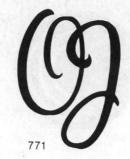

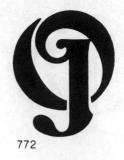

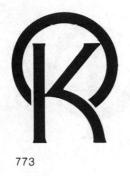

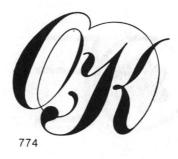

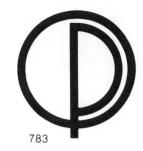

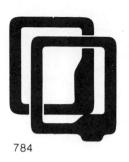

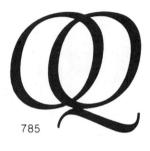

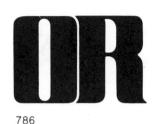

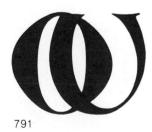

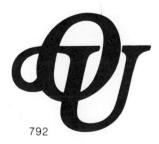

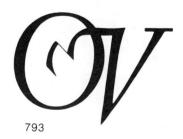

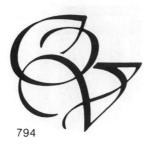

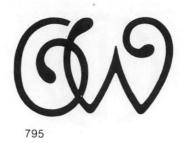

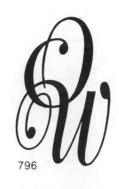

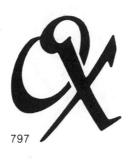

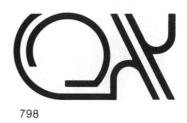

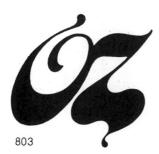

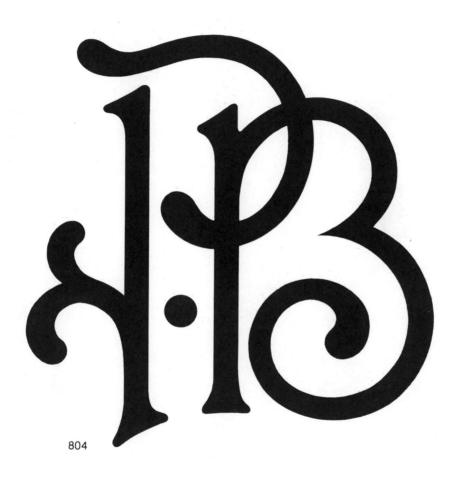

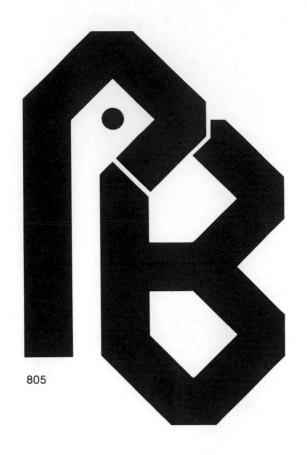

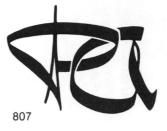

P 808

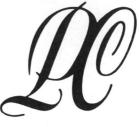

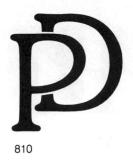

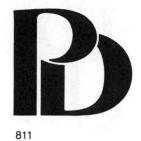

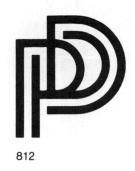

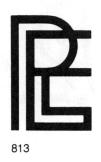

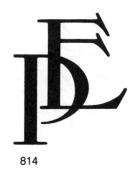

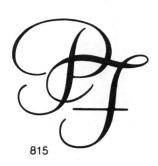

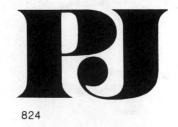

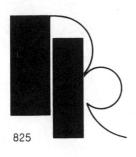

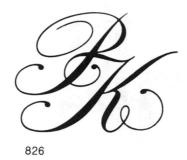

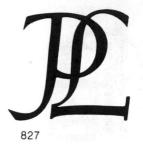

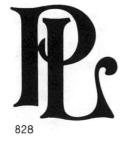

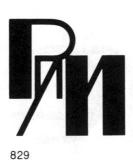

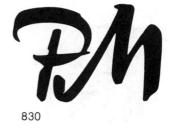

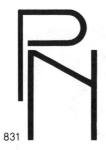

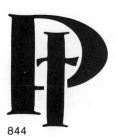

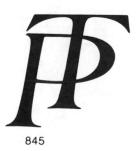

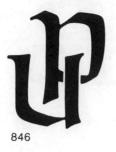

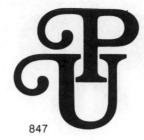

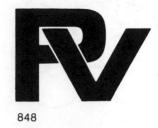

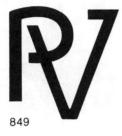

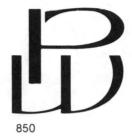

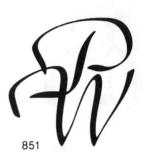

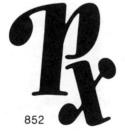

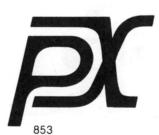

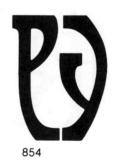

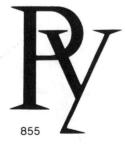

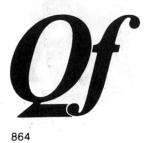

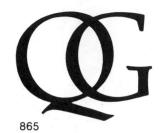

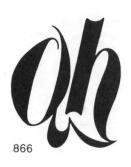

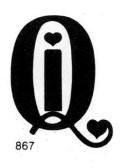

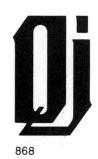

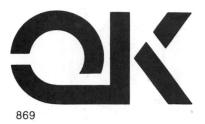

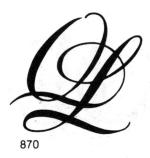

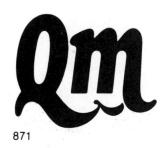

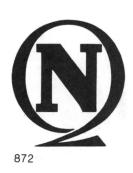

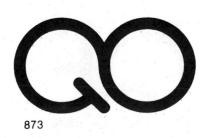

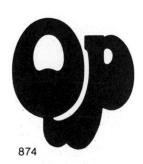

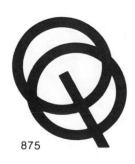

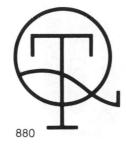

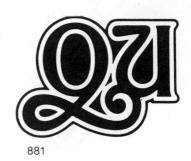

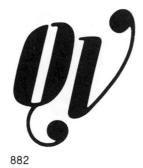

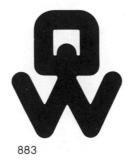

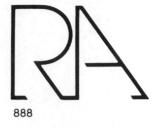

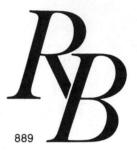

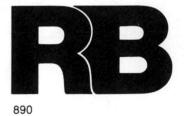

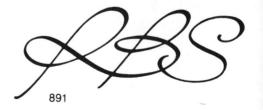

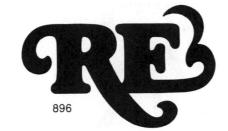

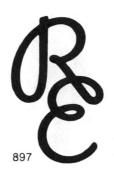

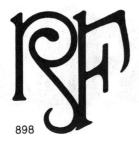

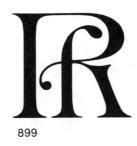

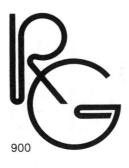

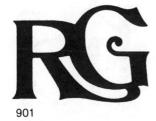

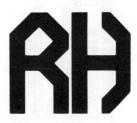

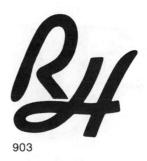

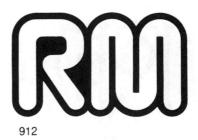

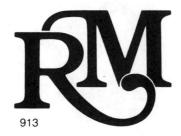

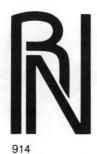

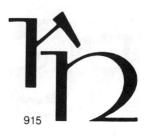

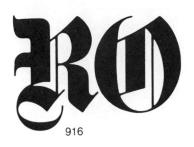

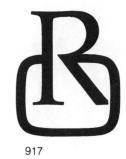

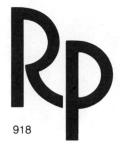

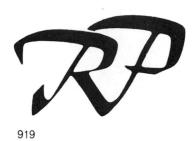

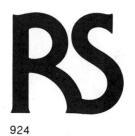

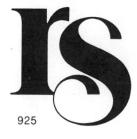

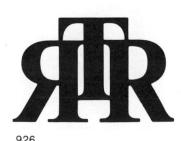

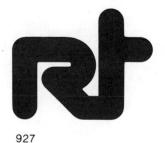

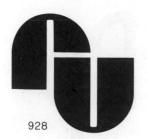

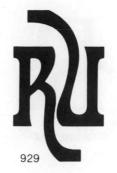

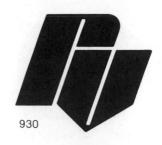

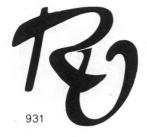

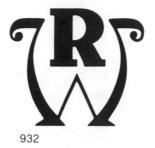

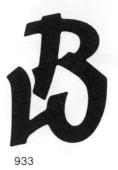

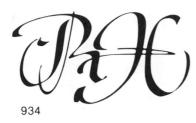

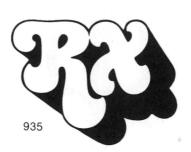

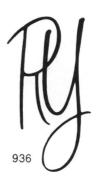

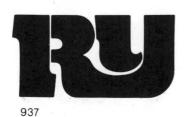

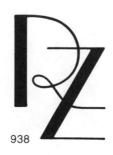

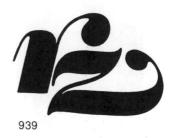

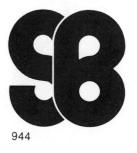

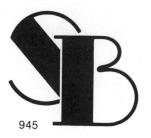

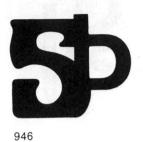

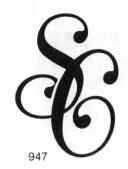

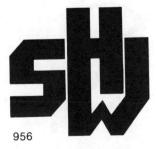

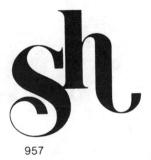

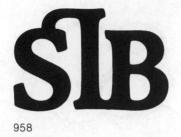

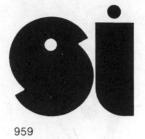

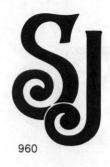

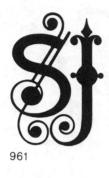

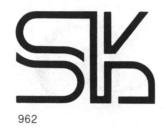

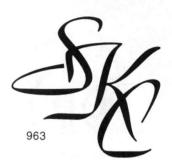

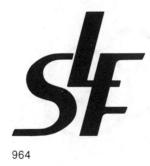

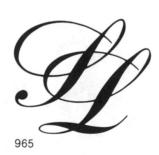

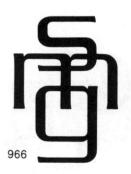

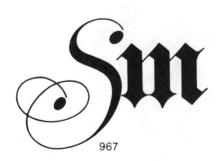

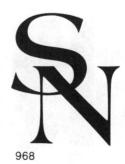

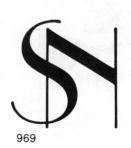

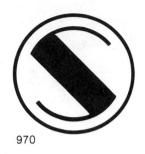

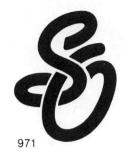

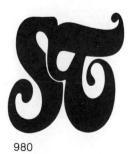

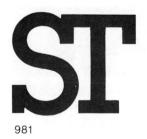

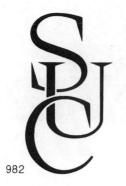

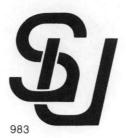

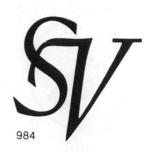

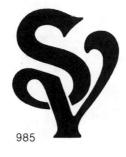

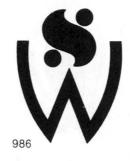

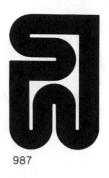

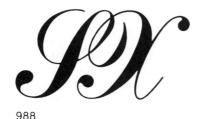

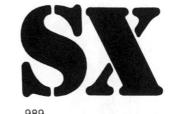

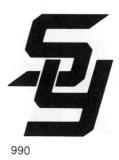

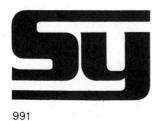

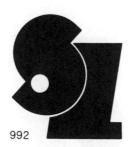

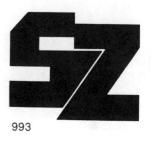

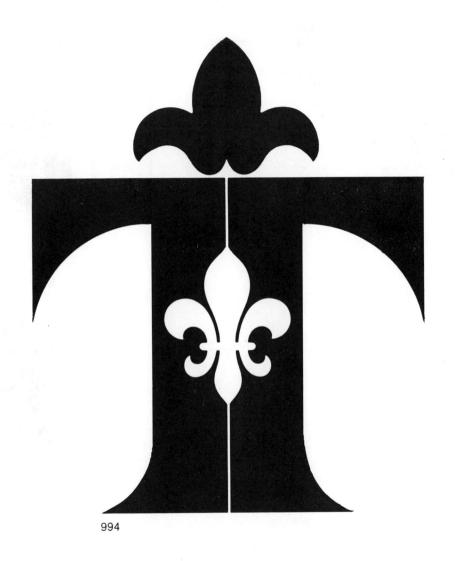

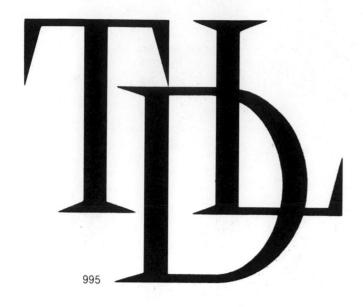

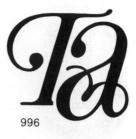

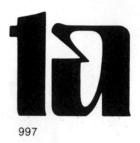

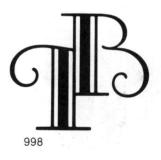

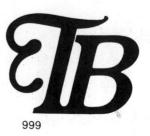

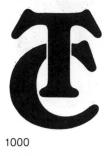

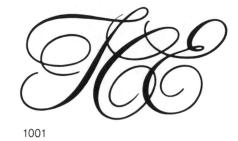

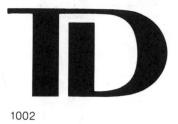

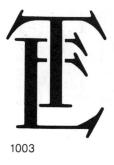

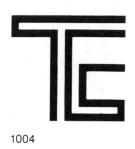

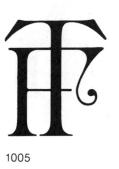

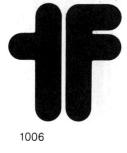

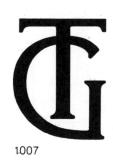

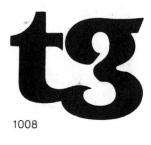

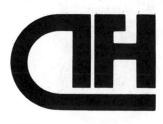

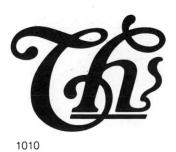

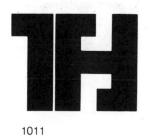

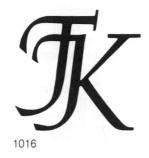

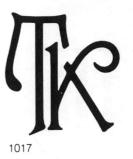

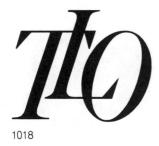

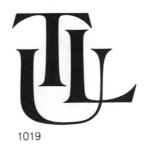

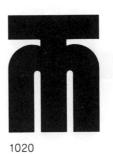

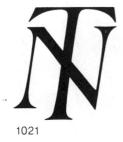

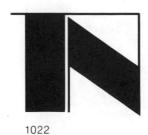

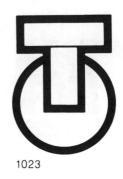

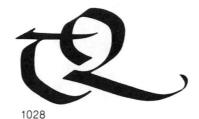

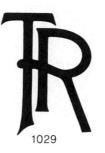

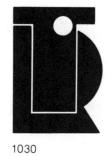

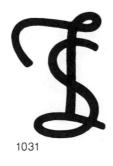

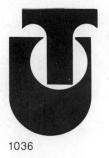

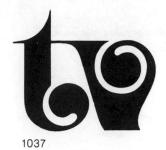

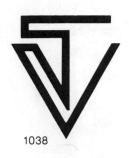

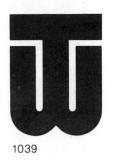

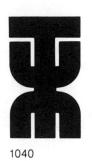

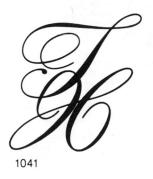

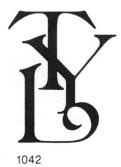

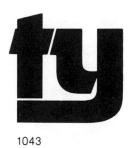

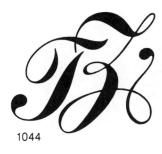

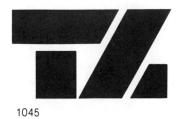

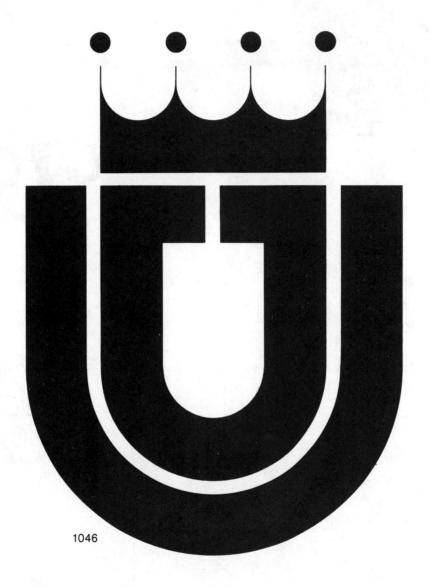

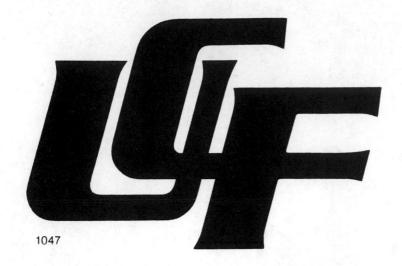

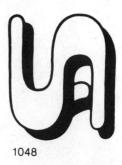

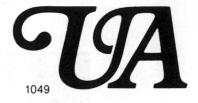

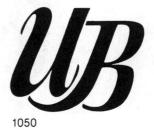

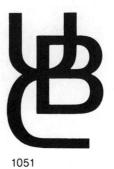

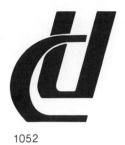

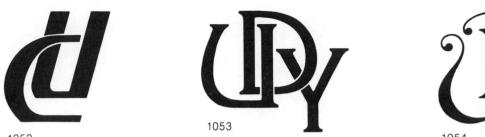

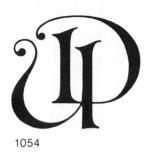

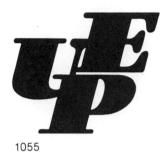

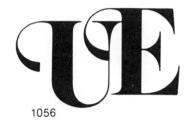

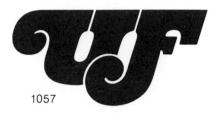

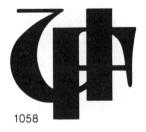

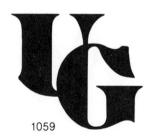

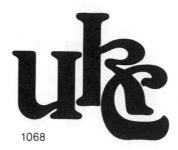

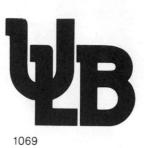

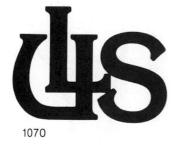

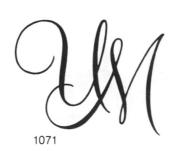

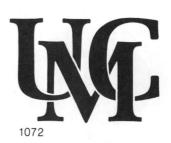

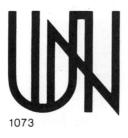

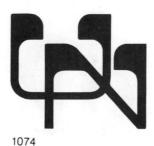

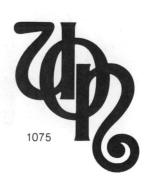

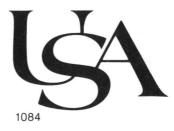

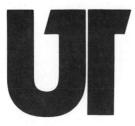

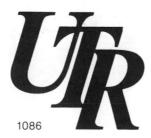

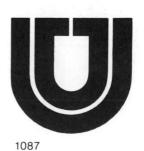

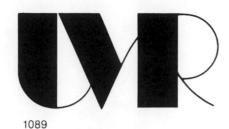

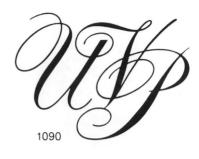

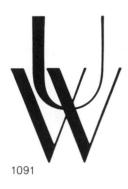

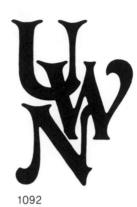

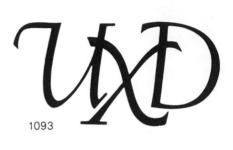

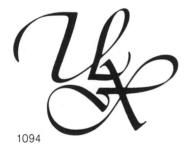

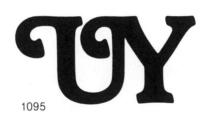

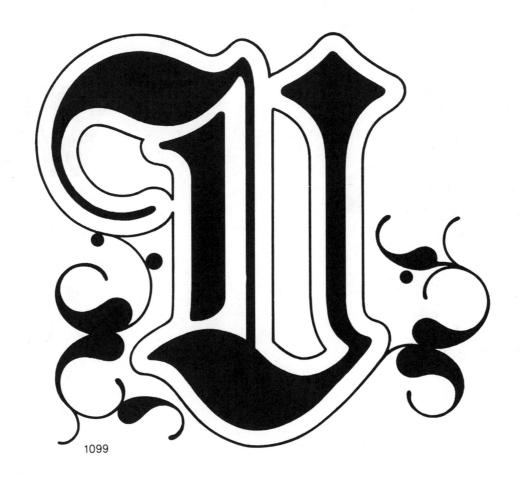

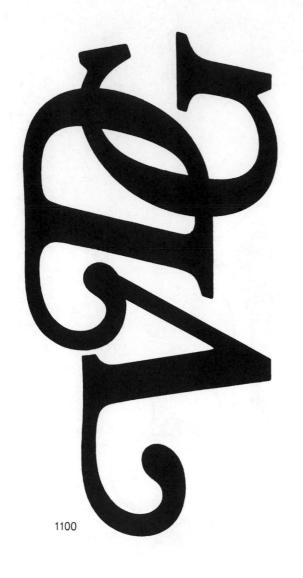

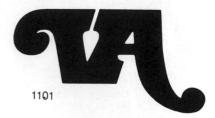

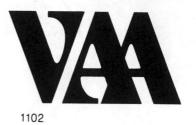

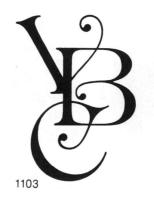

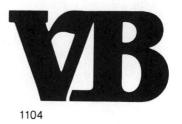

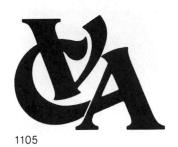

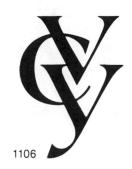

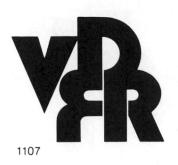

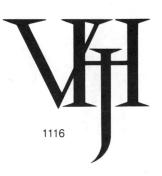

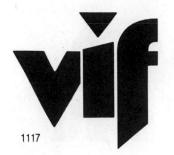

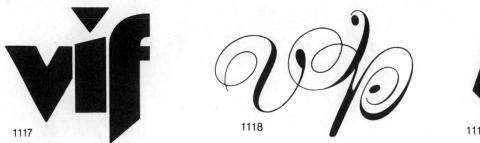

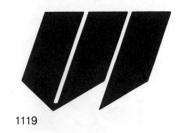

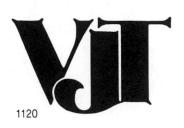

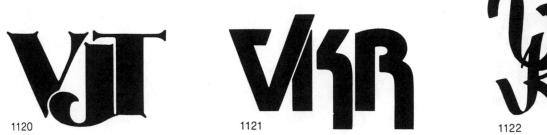

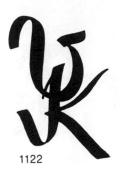

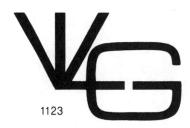

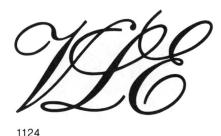

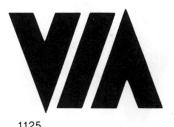

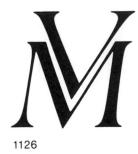

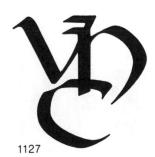

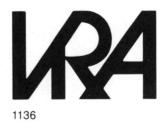

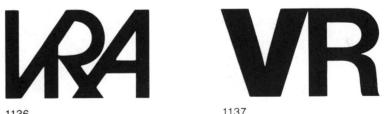

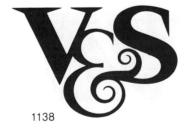

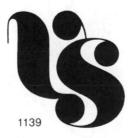

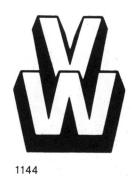

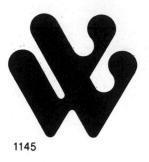

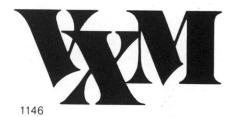

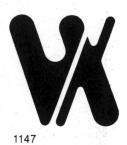

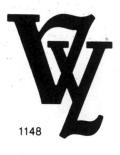

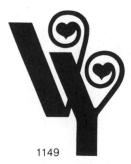

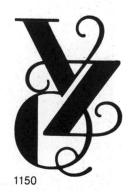

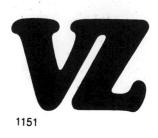

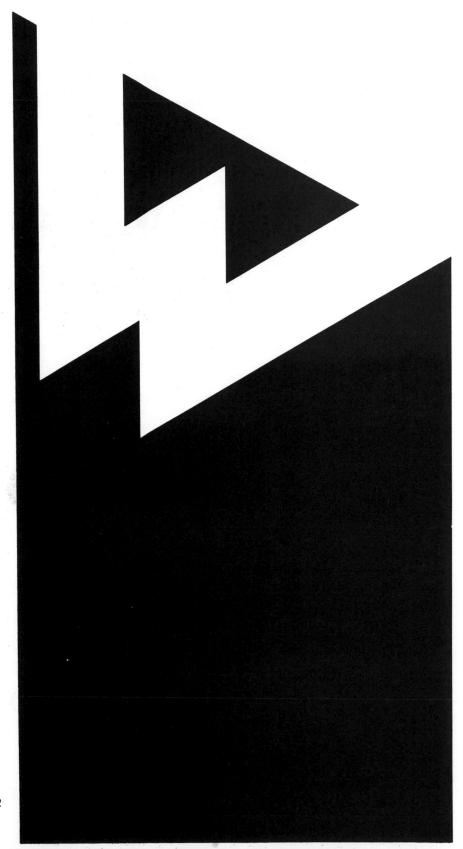

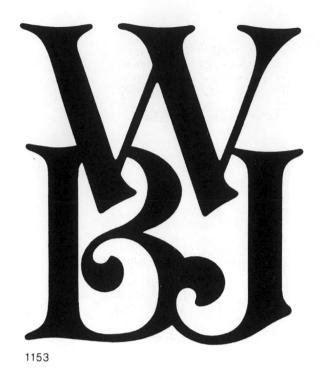

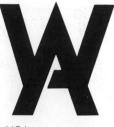

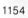

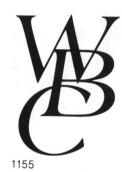

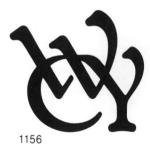

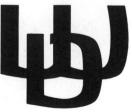

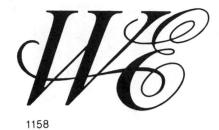

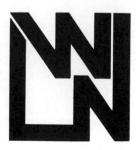

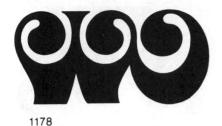

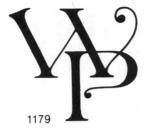

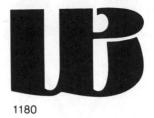

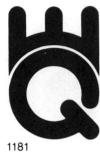

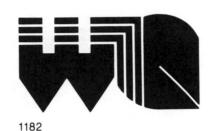

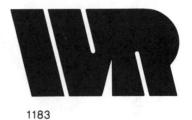

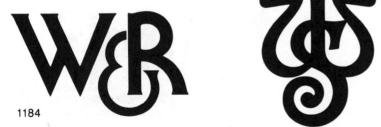

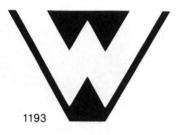

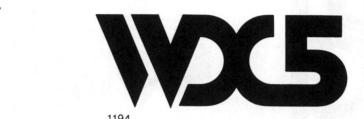

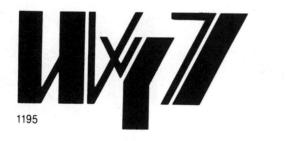

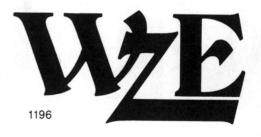

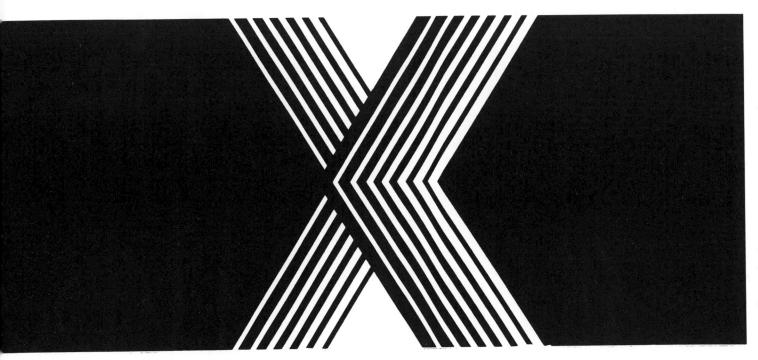

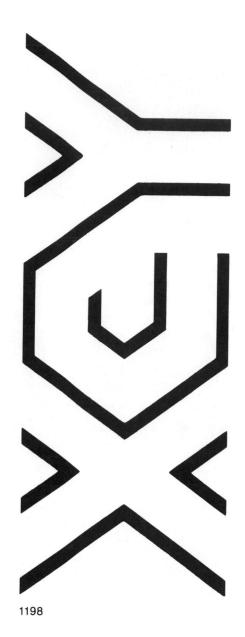

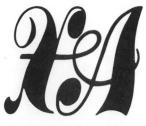

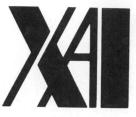

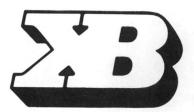

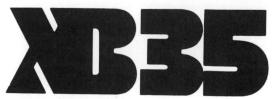

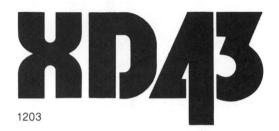

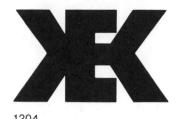

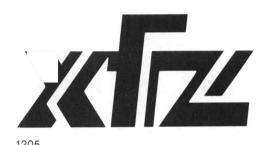

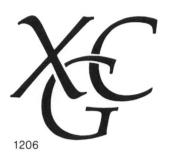

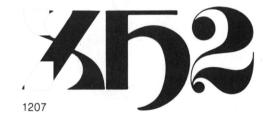

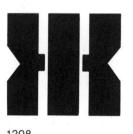

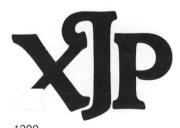

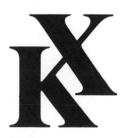

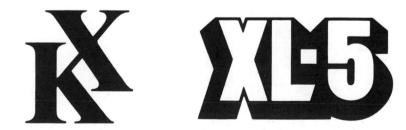

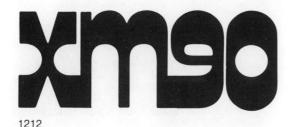

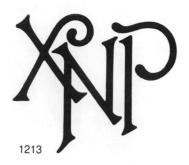

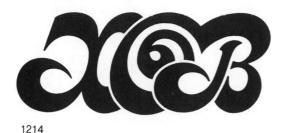

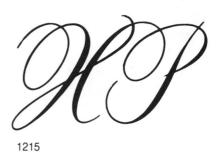

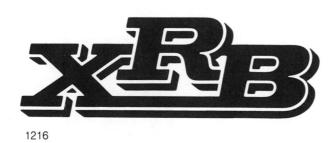

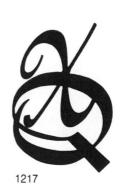

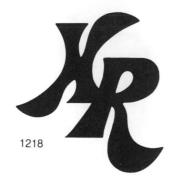

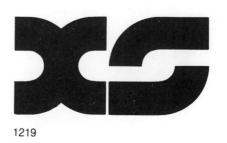

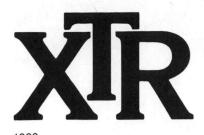

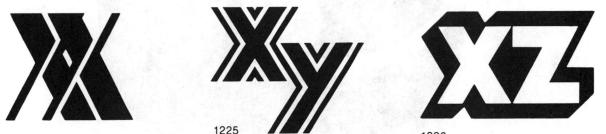

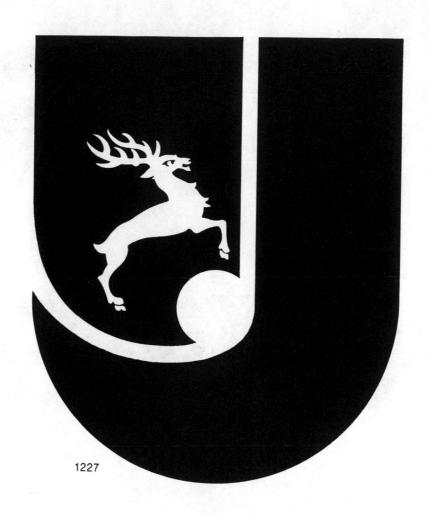

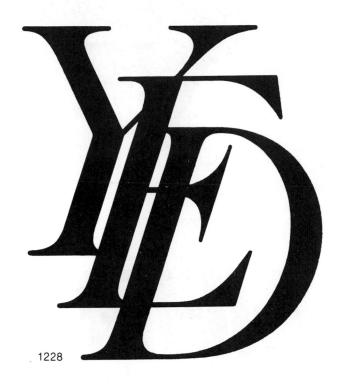

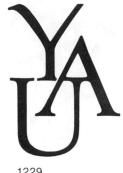

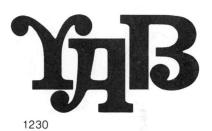

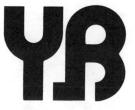

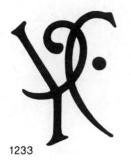

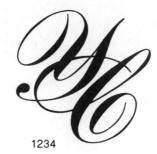

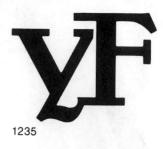

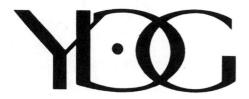

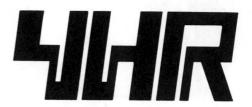

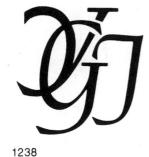

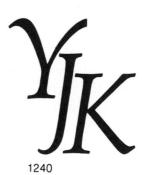

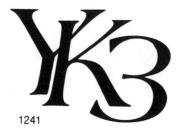

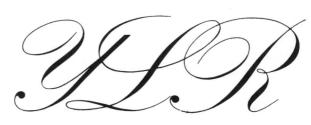

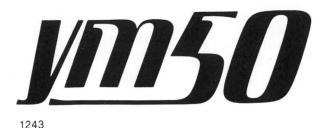

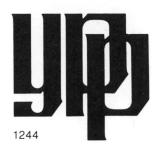

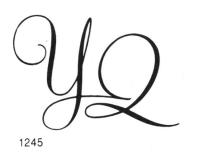

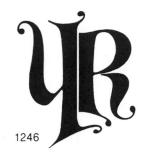

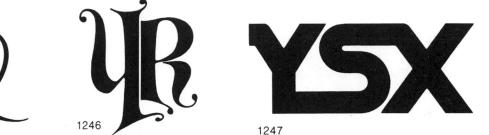

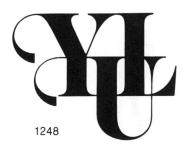

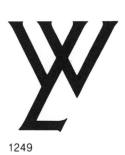

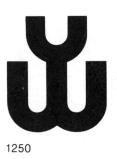

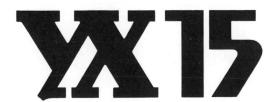

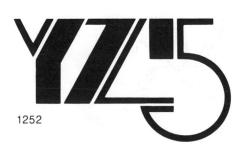

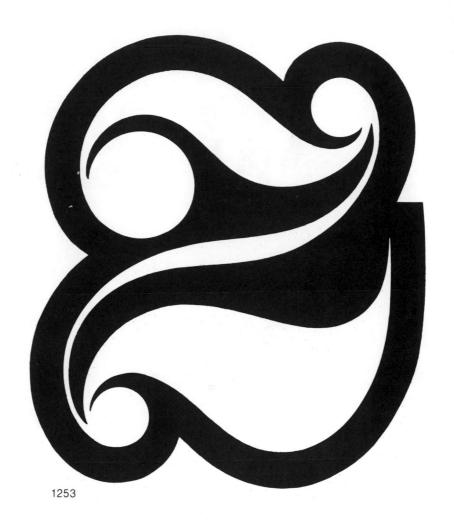

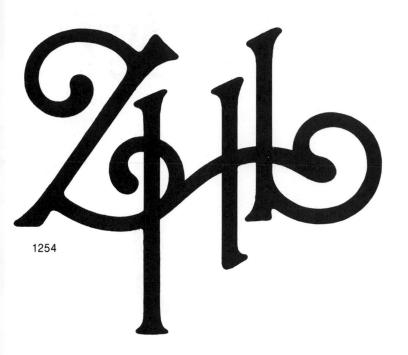

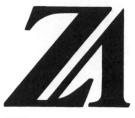

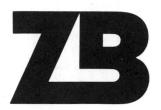

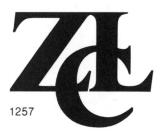

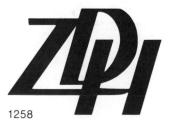

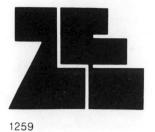

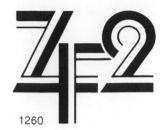

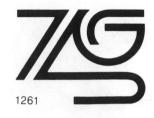

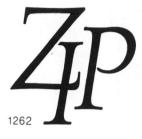

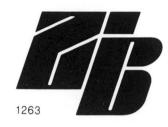

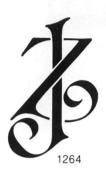

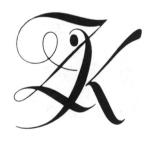

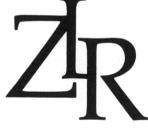

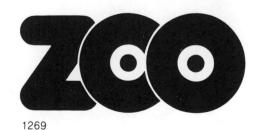

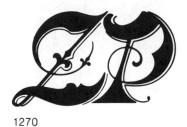

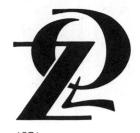

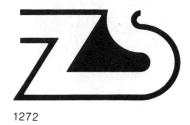

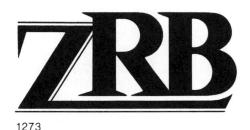

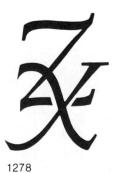

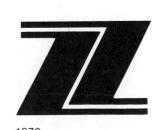

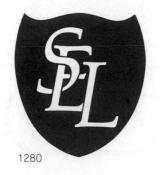

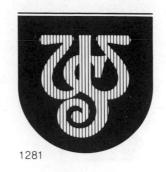

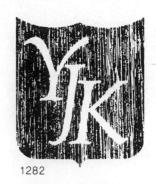

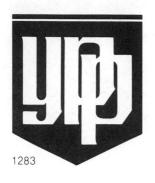

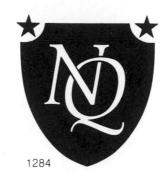

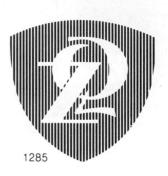

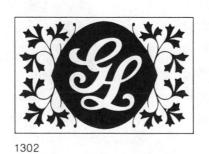

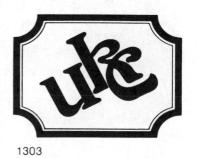

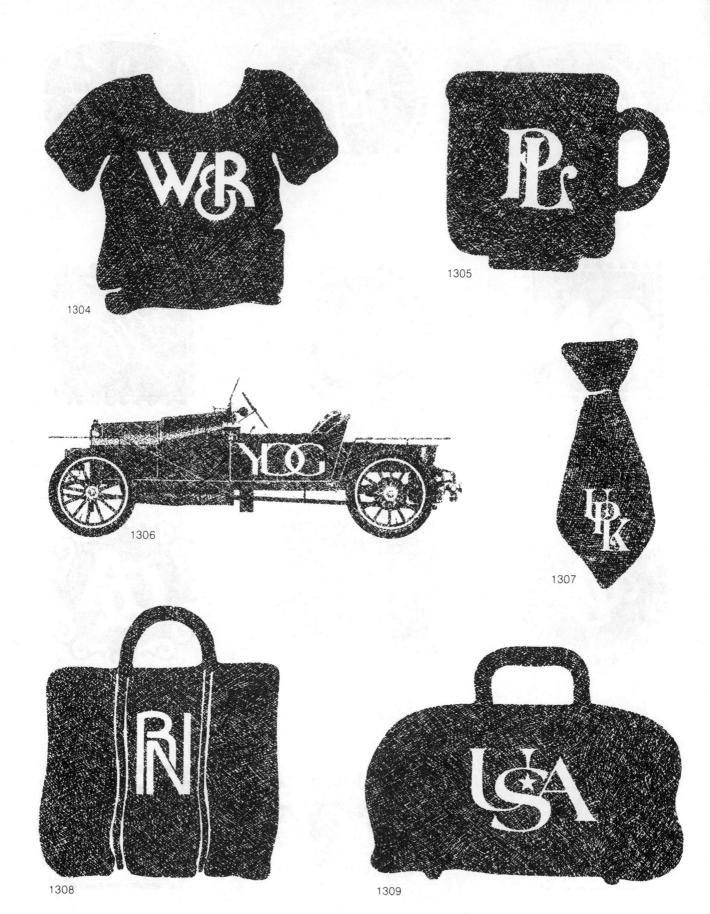

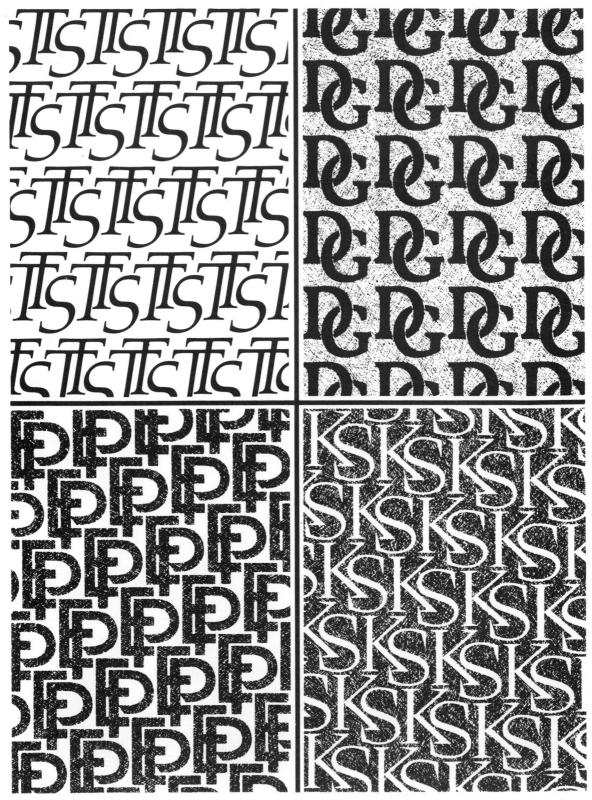

<i>r</i>			
·			
	*		

	(Property)		
- Apr			
•			
		*	